W9-CEI-879

Providence

PHOTOGRAPHS BY RICHARD BENJAMIN

Text by Katherine Imbrie

NEW ENGLAND LANDMARKS

COMMONWEALTH EDITIONS
Beverly, Massachusetts

The word *providence* has an antique flavor; it's not often used today except in arcane legal papers. But in 1636, religious rebel Roger Williams chose it for the name of the settlement he established on a steep hillside overlooking the confluence of two rivers at the headwaters of Narragansett Bay. Tossed out of the puritanical Massachusetts Bay Colony for advocating for the separation of church and state, Williams had traveled for many days through the wilderness before finding himself in what today is Rhode Island.

By naming his future home Providence, Williams was humbly recognizing God's grace in having provided him a safe haven, a sanctuary where he and

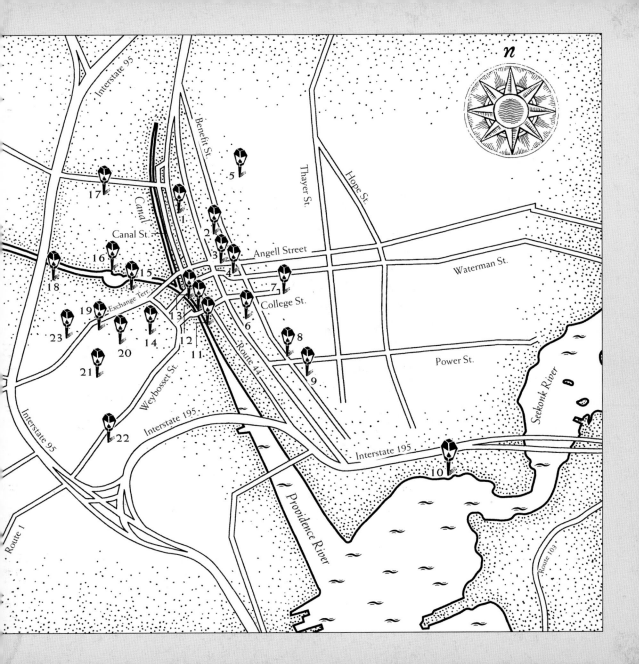

Copyright © 2005 by Richard Benjamin.

All rights reserved. No part of this book may be reproduced in any form or by any electronic or mechanical means without permission in writing from the publisher, except by a reviewer who may quote brief passages in a review.

Library of Congress Cataloging-in-Publication Data

Benjamin, Richard, 1939-

 Providence / photographs by Richard Benjamin ; text by Katherine Imbrie.

 p. cm. — (New England landmarks)

 ISBN-13: 978-1-933212-07-4

 ISBN-10: 1-933212-07-1

 1. Providence (R.I.)—Pictorial works. 2. Providence (R.I.)—Description and travel.

I. Imbrie, Katherine. II. Title. III. Series.

 F89.P943B46 2005

 917.45'20444—dc22 2005012098

Cover and interior design by Peter Blaiwas, Vern Associates, Inc.

Layout by Benjamin Jenness, Vern Associates, Inc.

Map on endpapers by Jeffery M. Walsh

Printed in South Korea.

Commonwealth Editions

266 Cabot Street, Beverly, Massachusetts

www.commonwealtheditions.com

Images from this book are available from Picture This Galleries, www.picturethisgalleries.com.

Contact Richard Benjamin directly at RBstockpix@aol.com.

Front cover: Skyline from Roger Williams statue at Prospect Terrace

Back cover: Gondola, with a reflection of the financial district

Page 6: Rendering of seventeenth-century Providence by Jean Blackburn, courtesy

 of the National Park Service and Roger Williams National Memorial

Quotation on page 23: Copyright © Mad Peck Studios 1978.

The New England Landmarks Series

Cape Cod National Seashore, photographs by Andrew Borsari

Walden Pond, photographs by Bonnie McGrath

Revolutionary Sites of Greater Boston, photographs by Ulrike Welsch

Boston Harbor Islands, photographs by Sherman Morss Jr.

his small band of followers would be free to practice a radical new brand of religion — one based on tolerance and acceptance of others' views.

Williams's settlement would prove to be a "lively experiment" (so described a few years later by his fellow colonist John Clarke), and one that would not be without risk, for Williams and his followers were setting up shop in the midst of what was then wild and untamed Indian country, home to the Narragansett tribe of the Algonquin nation. Fortunately, the outcast preacher's tolerant ways had earned him admiration and respect from the Narragansetts, whose chief sachem, Canonicus, welcomed him.

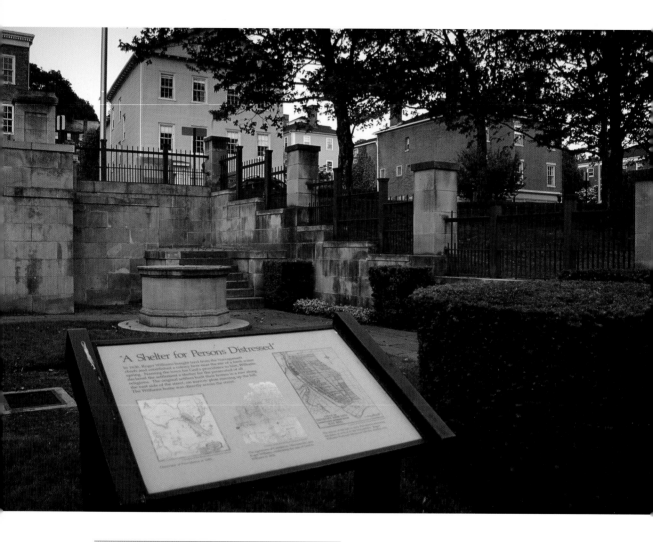

Site of the spring where Roger Williams first settled

HAVING OF A SENSE OF GOD'S MERCIFUL PROVIDENCE
unto me called this place Providence, I desired it might
be for a shelter for persons distressed for conscience.

—Roger Williams, 1636

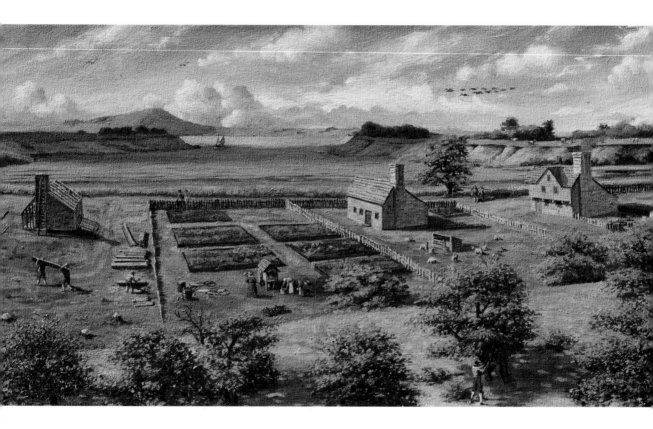

Artist rendering of seventeenth-century Providence by Jean Blackburn. Roger Williams's house is in the middle, near what is now North Main Street. Federal Hill is near the sailboats; the State House now sits on the hill on the right.

TO HOLD FORTH A LIVELY EXPERIMENT
that a most flourishing civil state may
stand and best be maintained with full
liberty in religious concernments.

—John Clarke, from the Rhode Island
 colony charter, 1663

THE FIRST BAPTIST MEETING HOUSE, THE FIRST IN AMERICA, stands in grandeur part way down the hill. Beside it are the Providence Art Club and Fleur-de-Lys Studio. A block or two farther along Benefit Street are the Arsenal and the Colony House, where Rhode Island's self-reliant Declaration of Independence was signed on May 4, 1776. At the beginning of our century, these buildings were the same as today.

—Margaret Bingham Stillwell,
 While Benefit Street Was Young, 1943

First Baptist Church, with Thomas Street and Fleur-de-Lys Studio beyond

HE SAW BEFORE AND BELOW HIM
in the fire of sunset the pleasant,
remembered houses and domes
and steeples of the old town;
and his head swam curiously. . . .

— H. P. Lovecraft, *The Case of
Charles Dexter Ward*, 1928

(overleaf) Polar bear exhibit, Roger Williams Park Zoo

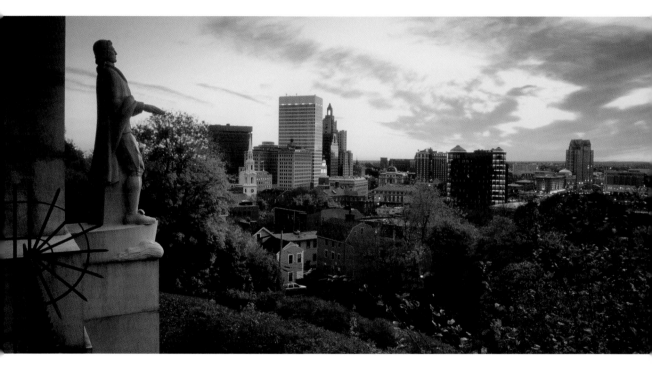

Skyline from Roger Williams statue, Prospect Terrace

As they navigate around the city, modern visitors to Providence can't help but notice the idealistic character of street names: Hope, Benevolent, Friendship, Power, Benefit.

Benefit Street, in particular, has a history that's intimately entwined with the city's. First dubbed "Back Street," it was laid out on a north-south axis, halfway up a steep hill at the base of which ran the settlement's original thoroughfare, Towne Street (now North and South Main streets). Each of Providence's original settlers owned a lot that fronted on Towne Street and climbed the steep hill behind it. But as decades passed and commerce increased, it became desirable to have vehicular access to the back of

these lots. In 1756, Benefit Street was laid out "for the benefit of all," to provide a route to the original back lots, where houses could then be built.

Two centuries later, these houses — neglected and allowed to fall into disrepair — were saved and restored through the concerted efforts of local citizens who formed one of the country's first architectural rescue groups, the Providence Preservation Society. Today, Benefit Street's "Mile of History" is the centerpiece of Providence's treasure trove of period houses. Thousands visit the city each year to stroll its brick sidewalks, time-traveling backward two and a half centuries to a period when Providence was a burgeoning seaport in a brand new country.

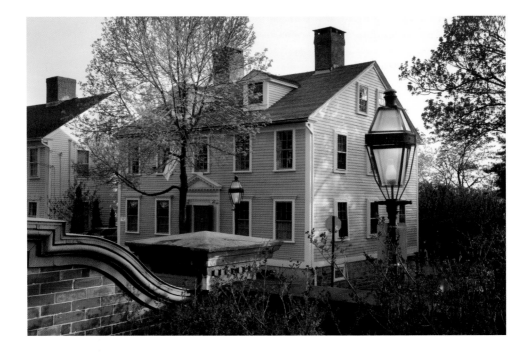

Evening on Benefit Street

GENERATIONS AGO, PEOPLE WERE BUILDING BUILDINGS that had art built into them, that had interesting and thoughtful architectural design. If you look at Benefit Street, it wasn't a fancy neighborhood, but it had master craftsmen working very carefully on what they were doing, and it shows. You have a feeling, a certain artistic integrity and strength.

—Barnaby Evans, interview in the *Providence Journal*, July 1996

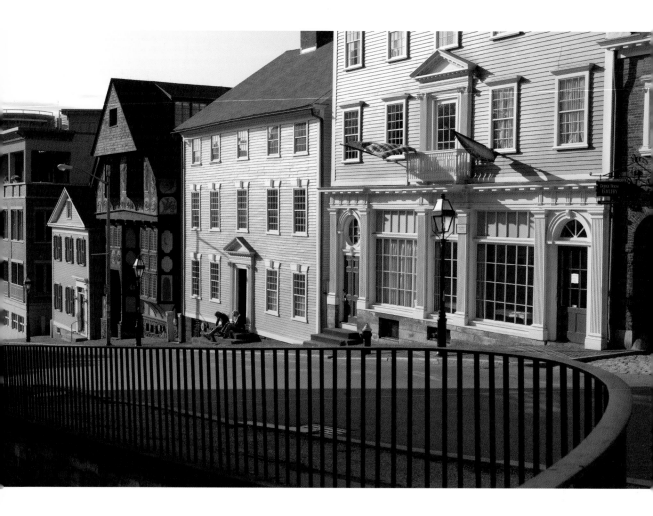

Providence Art Club buildings, Thomas Street

THOMAS STREET IN PROVIDENCE USED TO BE CALLED ANGELL'S LANE. It is a small street only three hundred and thirty feet long and it has but five houses fronting on it. Yet it has had a remarkably full and interesting history. It was once an unnamed path running up the hill from the Towne Street of the Providence Plantations. It belonged to Thomas Angell, the young companion of Roger Williams and one of the handful of refugees who settled on the banks of the Great Salt Cove in 1636.

—George Leland Miner, *Angell's Lane*, 1948

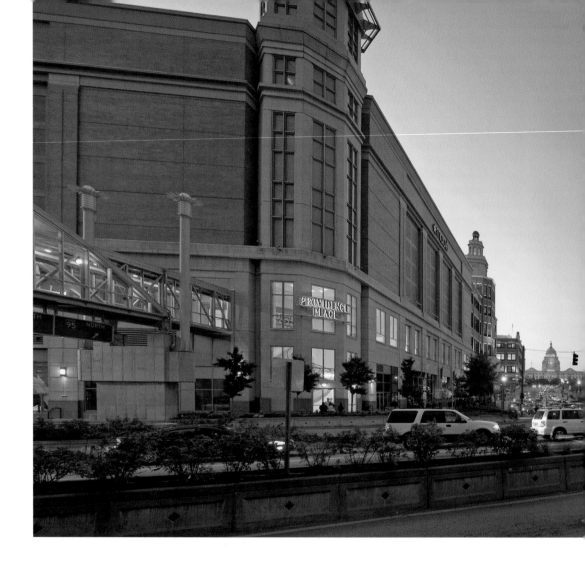

Capital Center, at the intersection of Memorial Boulevard and Francis Street

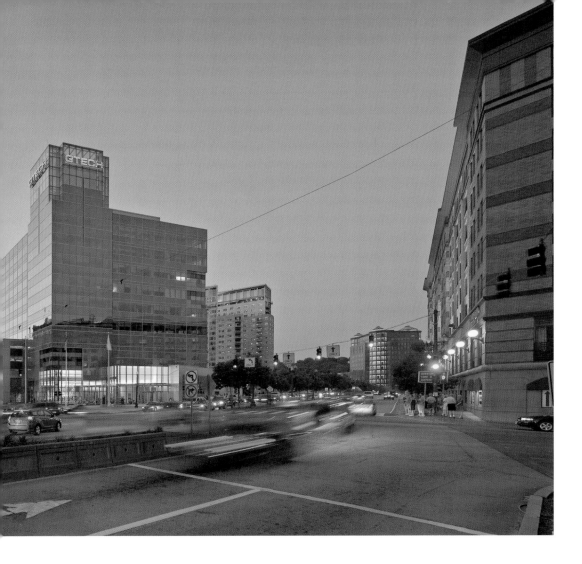

Rue de l'Espoir Restaurant, Hope Street

PROVIDENCE, RHODE ISLAND—WHERE IT RAINS
two days out of three, except during the rainy
season when it snows like a bitch, and Friendship
is a one-way street, rich folks live on Power Street,
but most of us live off Hope.

—Poster by Mad Peck Studios, 1978

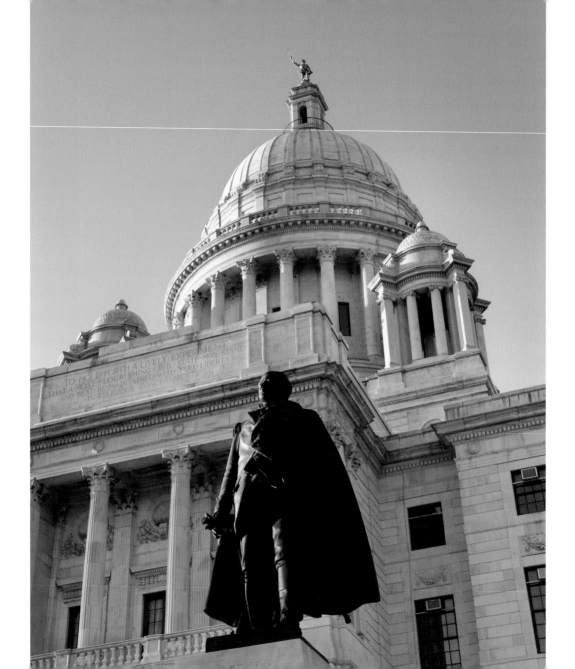

ALMOST BETTER THAN ANY OTHER STATE HOUSE IN THE COUNTRY [the Rhode Island State House] satisfies the aesthetic demands of variety and unity without the smallest sacrifice of character.

—Franklin Clarkin, commenting on the design chosen for the State House, *Harper's Weekly*, spring 1895

Statue of General Nathanael Greene in front of the State House

W here today a riverfront park and a street of upscale restaurants and shops line the Providence River, two centuries ago wharves of a mighty seaport hummed with activity. Positioned at the head of a vast bay opening to the Atlantic Ocean, Providence was perfectly situated to be an important link in the sea trade that created the fortunes of some of its prominent citizens — among them the Brown family, for whom the city's foremost university is named.

During the mid- to late 1700s, the four Brown brothers — John, Joseph, Nicholas, and Moses — became the major players in the establishment of Providence as a New England city second only to Boston in terms of education, architecture, and commerce. John Brown built a brick house

(appropriately, on Power Street) that at least one admirer, President John Quincy Adams, later called the grandest in the country: "the most magnificent and elegant private mansion I have seen on this continent."

Now open to the public as a museum house owned by the Rhode Island Historical Society, the three-story Georgian John Brown House sits high enough on College Hill that its owner could easily have kept an eye on the comings and goings of his ships — some of which, of course, would have been agents in the now-infamous Triangle Trade, the lucrative route connecting the wharves of New England's merchant princes with those of the rum-and-slaves ports of Africa and the Caribbean.

Neighbors Lane, East Side

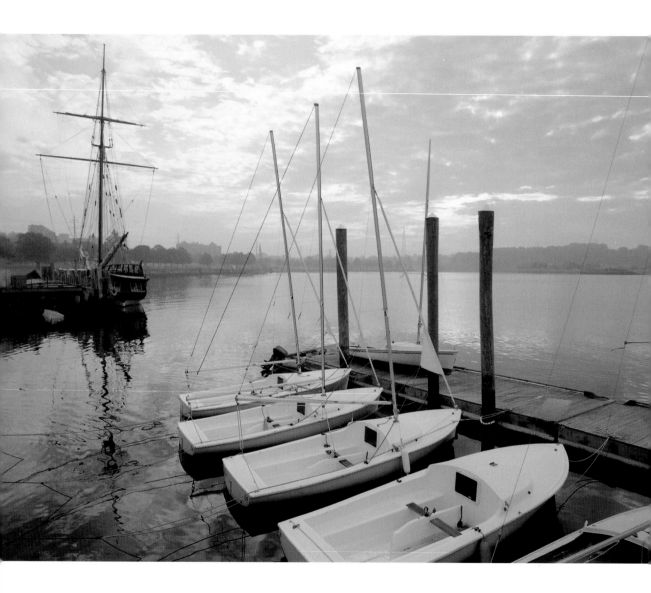

I NEVER CAN BE TIED TO RAW NEW THINGS,
For I first saw the light in an old town,
Where from my window huddled roofs sloped down
to a quaint harbour rich with visionings.

—H. P. Lovecraft, from *Fungi from Yuggoth*, 1929–30

Dawn at India Point, with a reproduction of the sloop *Providence* in the distance

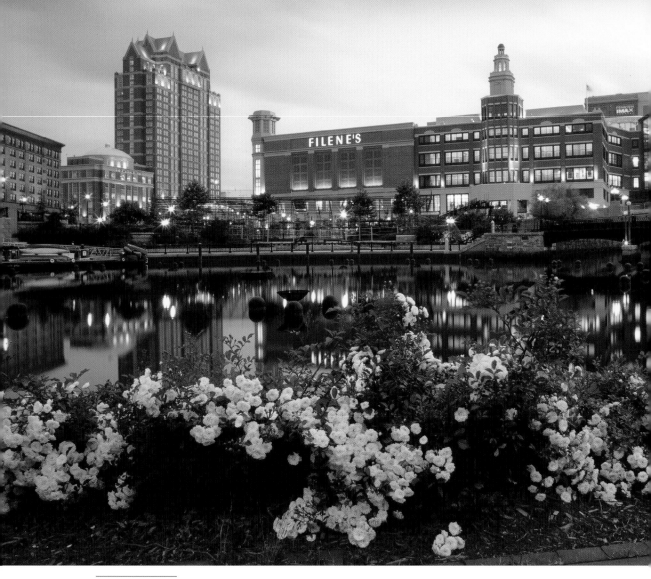

Providence Place

EVEN BY THE HARD-BITTEN STANDARDS of the rest of the Northeast in those days of oil crisis and post-industrial decline, Providence was notorious, its mills and factories shuttered, its docks and shipyards following suit, its city center lifeless, with once proud mercantile buildings standing dark and empty.

—Philip Gourevitch,
 The New Yorker, Sept. 2, 2002

YOU HAVE A CITY WITH ALL THESE
different people . . . all forced to
live with one another. I think
that's fun.

—John Cullen, quoted by
 Mike Stanton in *The Prince
 of Providence,* 2003

Strollers and diners on the Riverwalk

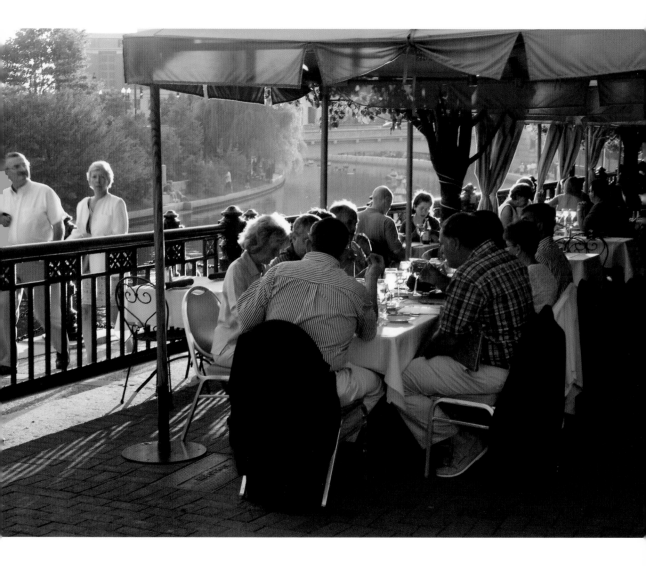

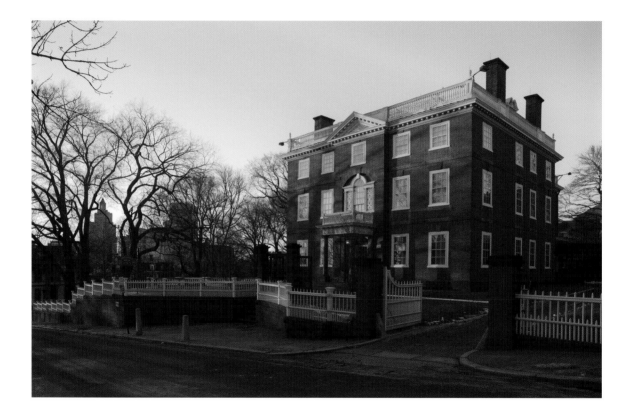

John Brown House, Power Street

PROVIDENCE—OUR PROVIDENCE—WAS STILL A TRANQUIL TOWN,

With apple trees and lilacs upblossoming to Brown,

With stately Georgian mansions that shamed the sunset's show

And pillars white as dogwood, and doorways like the snow.

—Henry Robinson Palmer, "A Hundred Years," 1930

AS IN NAPLES, THE OLD RESIDENTIAL SECTION of Providence spreads gradually up a high ridge rising abruptly from the water's edge. Houses, church spires, and graceful elms mass one above the other against the eastern sky. College Street cuts the ridge midway, its steep grade swerving from left to right as in horse-and-buggy days. Crowning it is Brown University. . . .

—Margaret Bingham Stillwell,
 While Benefit Street Was Young, 1943

Brown University

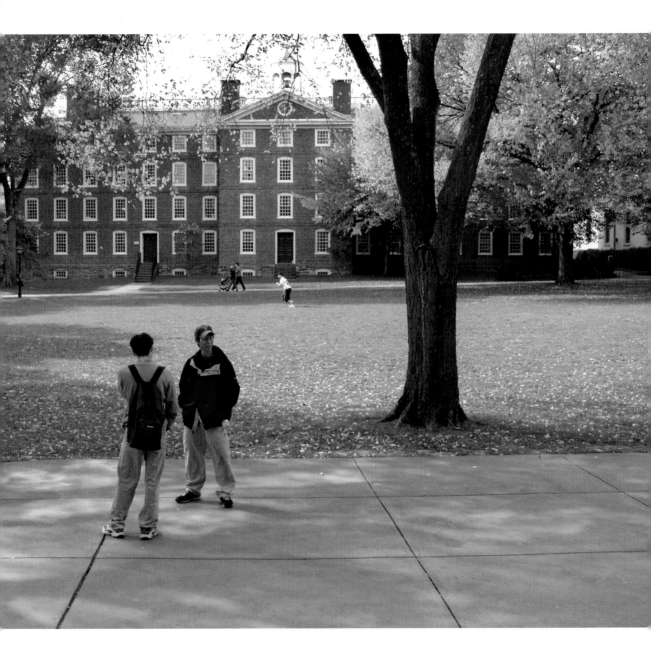

A series of natural and political catastrophes — including the War of 1812, which shut down the seaport for several years, and the Great Gale of 1815, which devastated its wharves — dealt severe blows to Providence as it entered the nineteenth century. But as the Industrial Age dawned, with textile mills upriver in Pawtucket and a new technique for plating metal to make tools and jewelry, the city kept humming.

Busy factories and mills attracted immigrants — mostly from Italy, but also from Portugal, Sweden, and French Canada. The city's ethnic complexion changed, from the English who had followed Roger Williams there, to southern Europeans who brought with them Old Country customs and tastes.

The west side of the city — the area now called Federal Hill — became a Little Italy of tenement houses and stores selling fresh-killed chickens, fragrant sausages, pungent cheeses, bottled olive oil, and other foods that

reminded immigrants of home. Today, many of these stores are still in business, joined by restaurants that make the several-blocks-long stretch of Atwells Avenue through Federal Hill one of the liveliest streets in Providence.

The Great Depression and World War II took the wind out of Providence's sails as factories closed and waves of immigrants found little work. For the first time, the city's population declined as emerging suburbs became more attractive to those seeking to escape the inner-city ills of corruption, crime, and poverty. The city looked tattered and threadbare, its once-thriving waterfront all but paved over, and its neighborhoods crumbling. A psychological low point came in 1983, when a *Wall Street Journal* profile of the city dubbed it "a smudge beside the fast lane to Cape Cod."

After that, however, a convergence of more favorable winds turned the city toward the renaissance for which it is celebrated today.

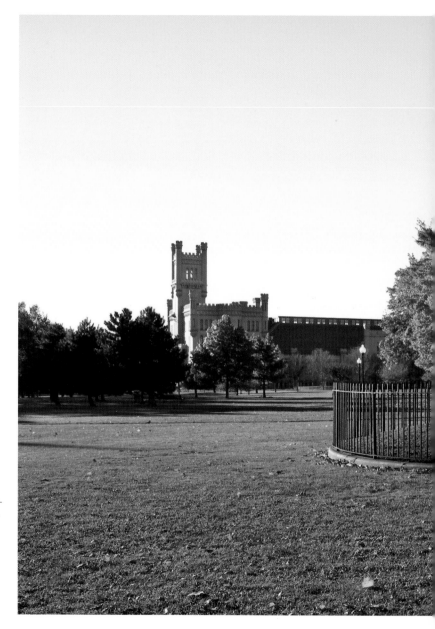

Dexter Training Ground,
with statue of Ebenezer
Knight Dexter and
Cranston Street Armory
in the distance

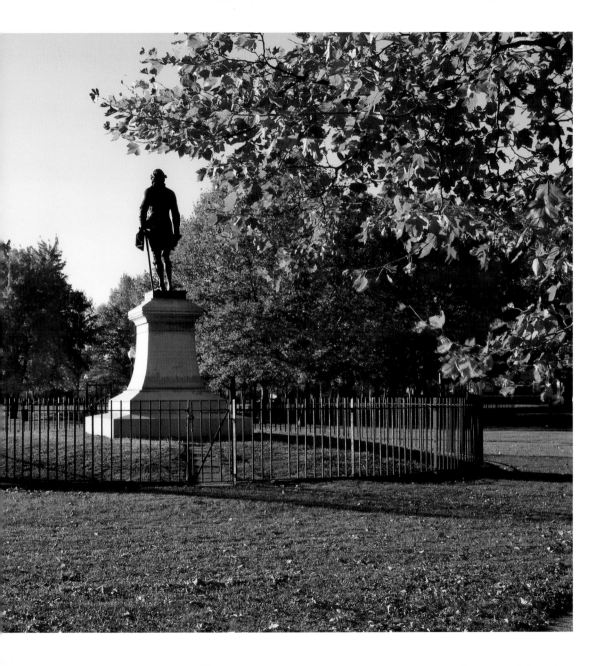

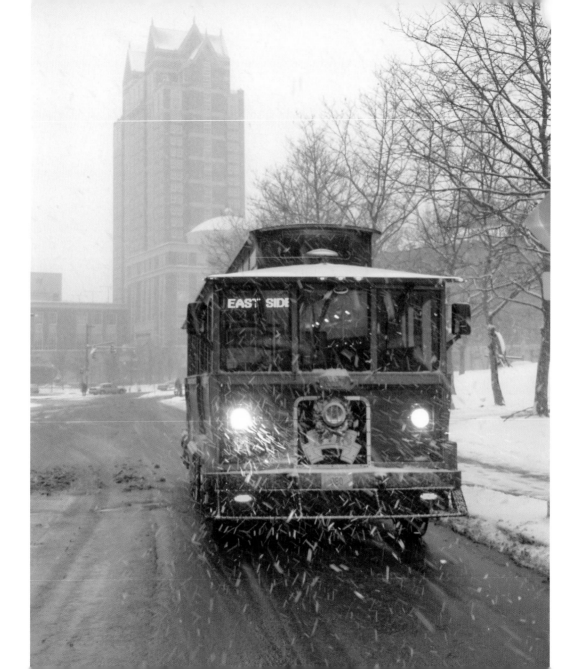

STREETS WITH CARVED DOORWAYS WHERE THE SUNSET BEAMS

Flooded old fanlights and small window panes,

And Georgian steeples topped with gilded vanes —

These are the sights that shaped my childhood dreams.

—H. P. Lovecraft, from *Fungi from Yuggoth*, 1929–30

New trolley recalls old times

IT'S THE BIGGEST SMALL TOWN I KNOW.

—John Cullen, quoted by Mike Stanton
in *The Prince of Providence*, 2003

DePasquale Plaza on Federal Hill

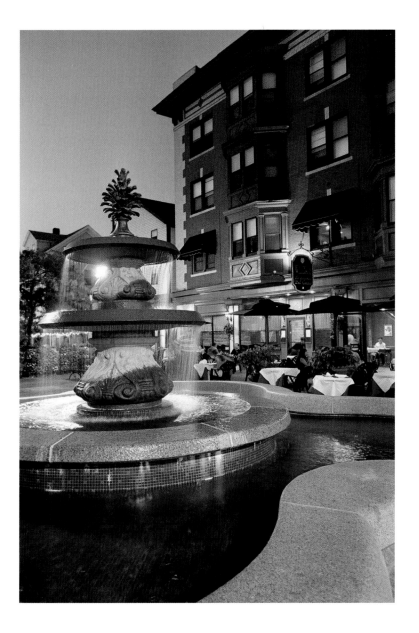

PEOPLE CRAVE THE ATWELLS AVENUES OF THIS WORLD, the Wickenden Streets of this world, the Thayer Streets of this world. They go to them even if they don't buy anything. They go and walk up and down them. People come in from the 'burbs for something or other. They go to the Coffee Exchange and then walk up and down.

—Urban planner Paul Murrain, interview in the *Providence Journal*, August 1997

Shop on Atwells Avenue

Beginning in the late 1980s and continuing through the 1990s, a combination of luck, timing, and civic enterprise turned what had been a wasteland—rail yards separating Providence's majestic State House from downtown—into the centerpiece of the Providence Renaissance.

The city's colorfully criminal mayor at the time was Vincent "Buddy" Cianci, who later would serve five years in prison on charges of racketeering. Though Cianci liked to take credit for the city's renewal under his watch, most analysts attribute it to a combination of factors, including creatively applied federal financing, forward-looking developers, and outside-the-box thinking by state and city planners.

In any case, the result is a startling transformation from the down-at-heels Providence of the 1970s to the high-stepping city of the present. Chief among the changes that made the difference was the uncovering and relocation to their original courses of the rivers that had formed the city's heart since its settlement. Over these revived waterways arch graceful foot and traffic bridges, and along them are cobblestone pedestrian river walks. In summer, two gondolas — faithful replicas of Venetian vessels — ply the waterways, and on certain evenings a hundred wood-burning braziers flame till after midnight along the rivers, accompanied by ethereal music and throngs of spellbound WaterFire watchers.

Waterplace Park

THE RAILYARDS ARE GONE, REPLACED IN PART BY A VAST, upscale shopping mall, in part by several new hotels, and, most strikingly, by the elegant Waterplace Park, an area of greens and stone promenades and canals that was created by excavating three long-buried rivers and rerouting them to wind—complete with bobbing gondolas—through the heart of the city.

—Philip Gourevitch, *The New Yorker*,
 September 2, 2002

[PROVIDENCE] IS ONE OF THE MOST SOPHISTICATED small towns in America. It has all the best urban experiences of New York, Chicago, or Boston, the dining and culture, without the negatives: congestion, urban anger, crime.

—John Cullen, quoted by Mike Stanton
 in *The Prince of Providence*, 2003

Strollers along the Riverwalk

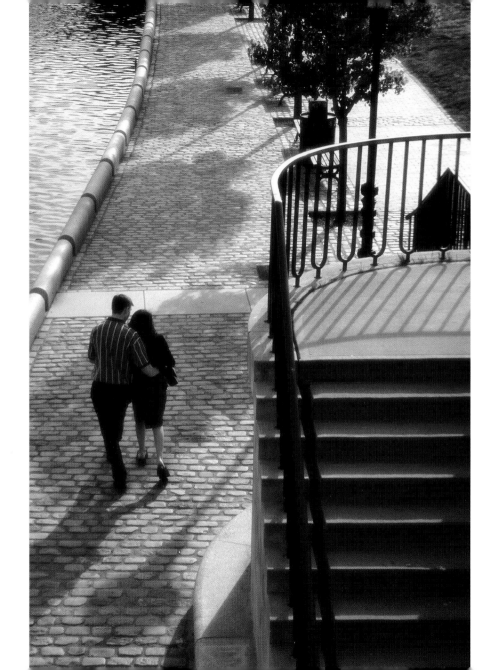

The Providence Athenaeum, where Edgar Allen Poe courted a ladyfriend

(overleaf) Gondola passing First District Courthouse

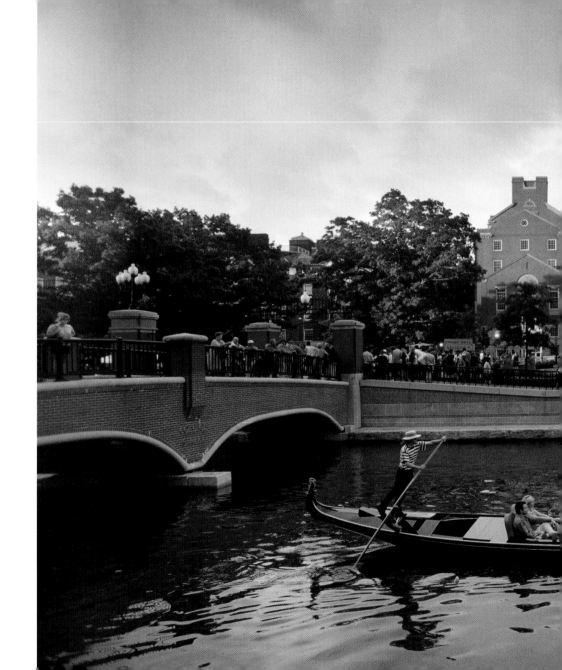

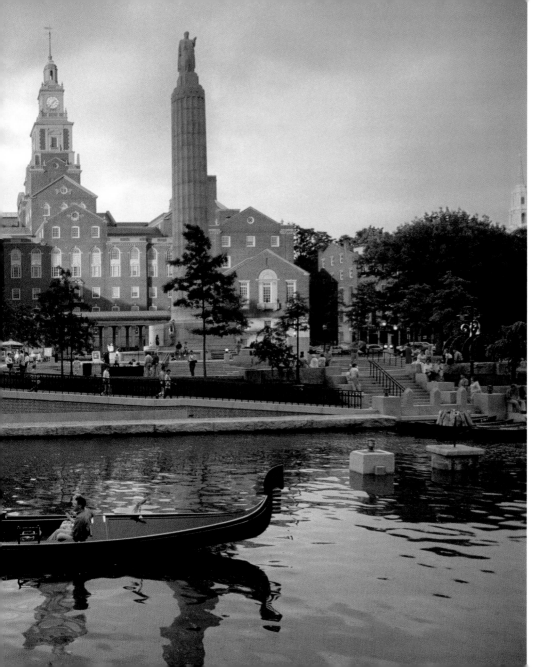

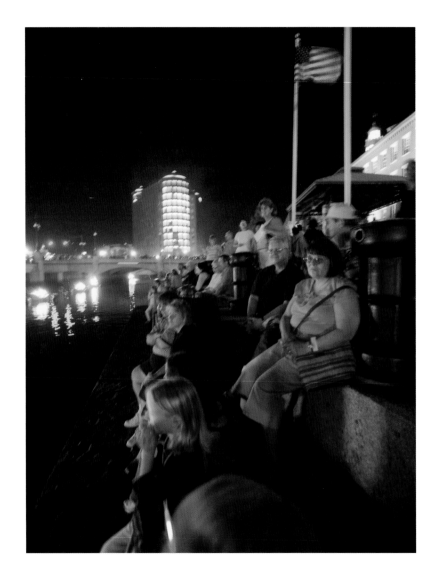

THE REASON WE BURN THE PINE IS FOR THE SCENT.
It also is what makes the sparks and the snap
and crackle in a fire. . . . All those, and the
smell of the smoke . . . triggers memories. It
smells like a campfire, so people remember
camping. It's also making reference to commu-
nity celebrations and rituals.

—WaterFire creator and artist Barnaby Evans,
interview in the *Providence Journal*, July 1996

Spectators enjoying WaterFire

WaterFire — the bonfires-on-the-rivers spectacle created in 1994 by Providence artist Barnaby Evans — has since become a magnet drawing people to the city from out-lying towns, other states, even other countries. They come for the excite-ment of an outdoor event that is both communal and primal: What could be more elemental than fire and water?

In winter, WaterFire goes on seasonal hiatus, yielding center stage to Downcity's outdoor ice rink. At lunchtime, office workers lace up their skates to spin and turn on the oval of white ice, set in the bowl of distinc-tively shaped buildings that give the city its unique skyline. (One is com-monly dubbed the Superman building, because it resembles the Gotham tower from which the comic book hero leaped.)

Even before its Renaissance, Providence was celebrated as a restaurant town. A steady stream of graduates from Johnson & Wales University and

the Rhode Island School of Design perpetuates the city's prominence as a proving ground for top-flight chefs and emerging artists.

Theater productions by the Tony Award–winning Trinity Repertory Company, touring musicals at the Providence Performing Arts Center, alternative arts at AS220 — all were Providence attractions long before the new upscale mall called Providence Place opened in 1999.

Perched between old downtown — Downcity — and the pristine marble dome of the State House, the mall is a neighborhood unto itself, complete with restaurants, shops, and movie theaters. It joins the city's established neighborhoods — Wickenden Street, Thayer Street, Federal Hill, and the Broadway Armory district — in looking toward a future that was forecast as early as 1663 by Rhode Island colonist John Clarke as "a lively experiment."

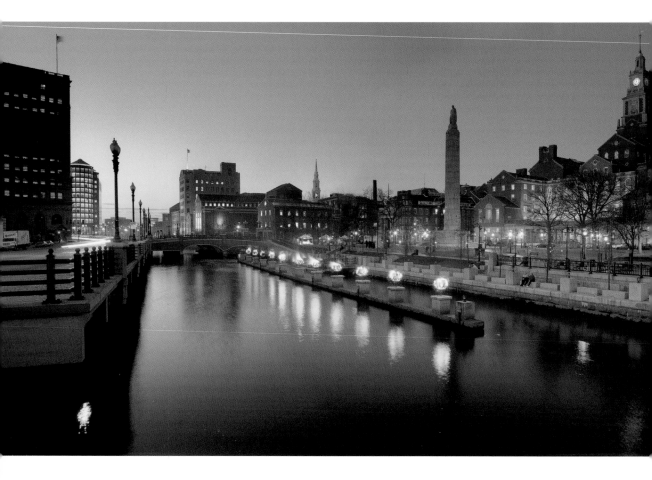

WaterFire early in the season

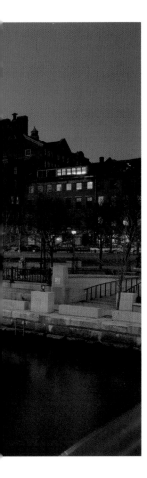

I WANTED TO CREATE AN INSTALLATION PIECE
that would animate that entire section of
the river, so that people would see it in a
new light and form a new attraction for the
river. . . . We're social animals. . . . We like
to be where people are. And then things
start to happen.

—WaterFire creator and artist Barnaby
 Evans, interviewed in the *Providence
 Journal*, July 1996

FREQUENTLY ON WINTER DAYS WE WOULD COAST DOWN HALSEY STREET, starting at Congdon Street, swinging around the curve, and down to Benefit. Then the great thing was to turn a sharp angle, either left or right, and to see how far we could go on the level. Not so dangerous as it seems, for whenever a cutter or a box-sleigh came along, there were always sleigh bells to warn us in time to dump off in a snowdrift.

—Margaret Bingham Stillwell, *While Benefit Street Was Young*, 1943

Skating in front of City Hall

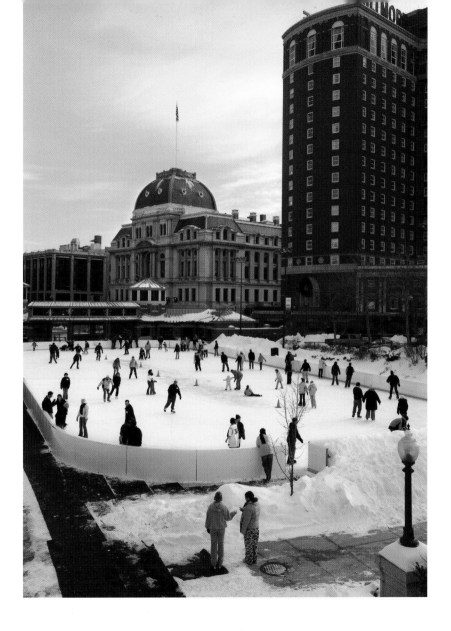

ONE MAY OVERHEAR THE ACCENT OF A BOSTON BRAHMIN, or of a New Yorker; but it is unlikely that a "pure Providence" tongue will be encountered, because there "ain't no such animal."

—From *Rhode Island,* by the
 Federal Writers' Project, 1937

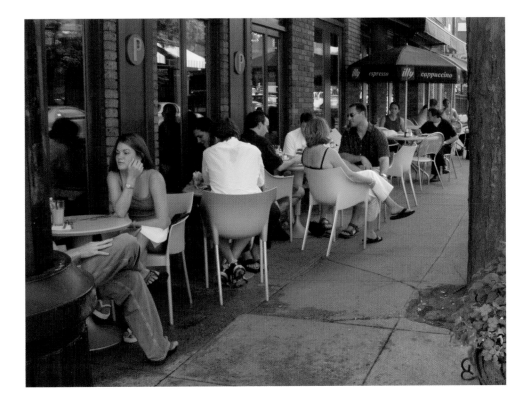

Diners at the corner of Thayer and Angell streets

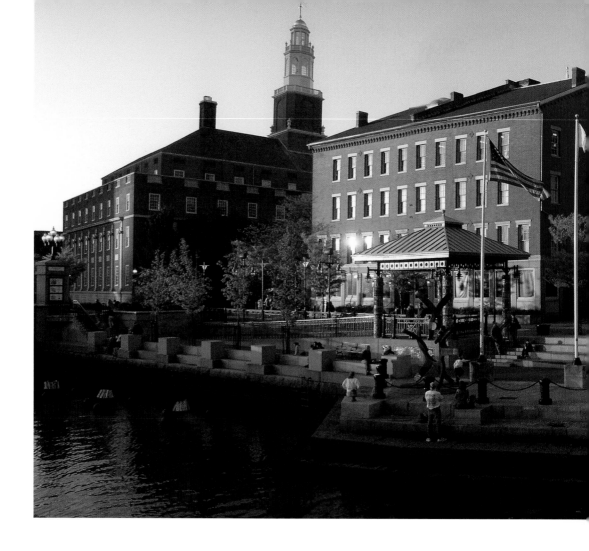

Riverfront Campus, Rhode Island School of Design

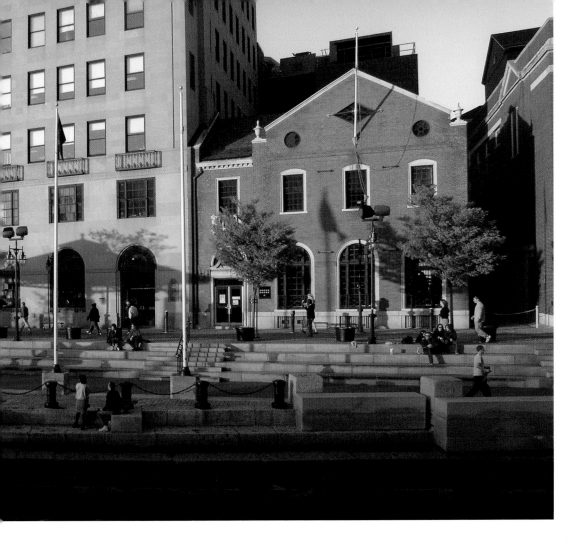

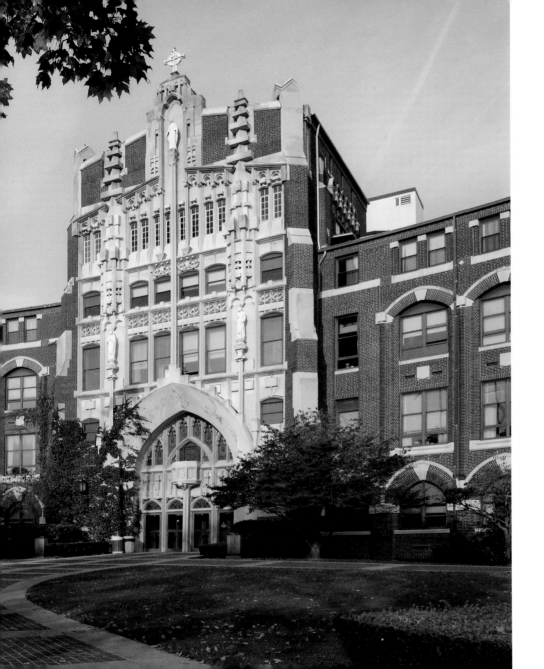

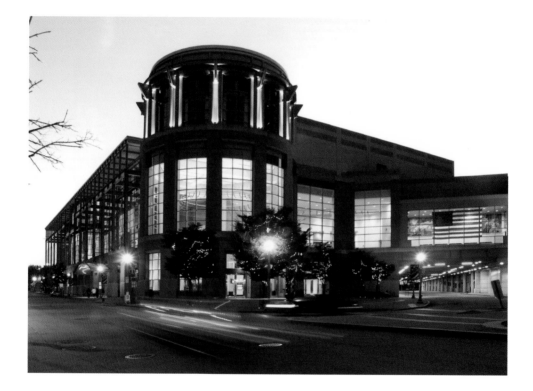

(*overleaf*) Providence College

Rhode Island Convention Center

THE POLICY HALLMARK OF THE PROVIDENCE RENAISSANCE:
that when opportunities arose, the right people in the
right place at the right time had what appeared to be the
right idea and were willing to show the requisite amount
of leadership to try to bring that idea to fruition.

—Francis J. Leazes Jr. and Mark T. Motte,
　Providence: The Renaissance City, 2004

AN AREA SO CONCENTRATED AS THIS ONE IS FILLED DURING THE BUSINESS DAY with a great variety of peoples. A random stroll up Westminster Street— past the principal banks, a bookstore, an elaborate pharmacy and two chain drugstores, a haberdashery, a "five and ten" block, past restaurants, shoe stores, dress shops, and the department store whose sidewalk clock is a popular rendezvous—presents an indescribable mixture of faces, complexions, attires, and manners of speech.

—From *Rhode Island,* by the Federal Writers' Project, 1937

Interior, Providence Place

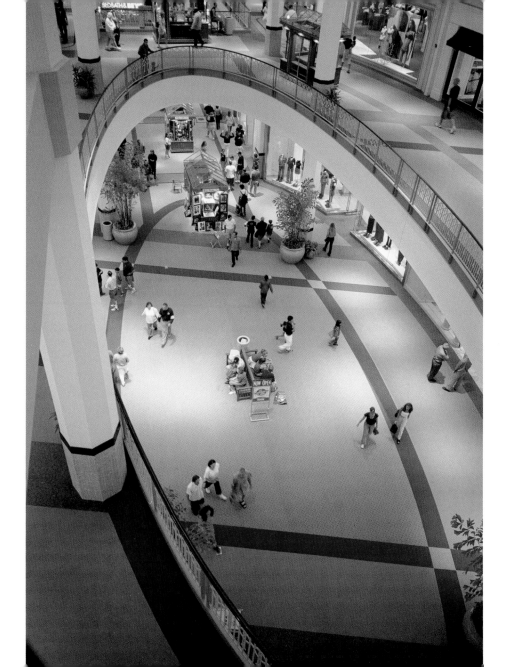

PRESERVATION IS NOT JUST ABOUT PRESERVING BRICK AND MORTAR,
lintel and beam. It is about the quality of life and the possibility
of a bright future.

—Former governor and U.S. senator John Chafee, 1999

Gondola, with a reflection of the financial district

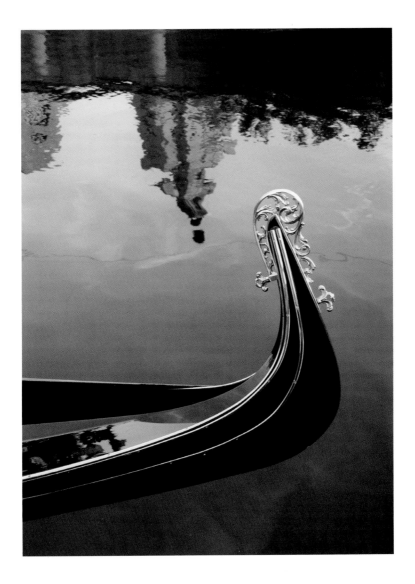

NOTE FROM THE PHOTOGRAPHER

THIS BOOK IS DEDICATED TO THE MEMORY OF MY SON DAN, WHO LOVED LIVING IN Providence. In 1993, nine months before passing away, by introducing my work to Picture This Gallery and Framing Center, he started a chain of events that eventually led to this book and many other things. I would also like to thank my wife, Trauti, and son Mike for their much-appreciated encouragement and support over the years. Trauti has put up with my odd working hours and my obsession with the beauty of snowstorms—and understands the phenomenon of "great skies" that shape up in mid-afternoon, requiring a rescheduling of dinner-time. Without my family's support and encouragement, this book would not be.

I must acknowledge my trusted friend and advisor, David O'Brien at Picture This, for representing my work over the years, allowing me to do what I love to do. There is a direct connection between the display of my work at the galleries and the realization of this book.

Special thanks to a great neighbor, Arthur Cabral, who, without being asked, has kept my driveway clear during many a snowstorm, giving me the time and energy to go out and do my work.

I would like to thank Kate Imbrie, a fondly remembered colleague at the *Providence Journal,* for her enlightening description of the city of Providence and her selection of such exceptional quotations. Her words add another dimension to the photographs.

Many thanks to Webster and Katie Bull, Penny Stratton, Anne Rolland, and all the staff of Commonwealth Editions for the opportunity to do this book and for being so easy to work with. Thanks are also due to Peter Blaiwas and Benjamin Jenness of Vern Associates, who handled the book design and layout.

Photo by Trauti Benjamin

RICHARD BENJAMIN is a native of Woonsocket, Rhode Island. In 1960, he left Brown University and became a publicity photographer while serving with the U.S. Army in Germany. He was a photojournalist at the *Times Union* and *Democrat & Chronicle* newspapers in Rochester, New York, and *Newsday* on Long Island before joining the *Providence Journal and Evening Bulletin* in 1969. Benjamin took early retirement from the *Providence Journal* in 1996 and began a second career as a landscape photographer. He lives in Rehoboth, Massachusetts.

KATHERINE IMBRIE has been a features writer for the *Providence Journal* for twenty-five years. She is the coauthor, with Phyllis Méras, of *An Explorer's Guide to Rhode Island.* She lives in Barrington, Rhode Island.

PROVIDENCE

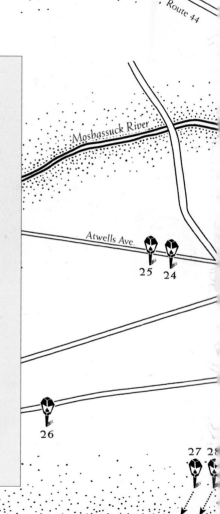

Route 44

Moshassuck River

Atwells Ave.

25 24

26

27 28

29